MIX YOUR OWN
ACRYLICS

AN ARTIST'S GUIDE TO
SUCCESSFUL COLOR MIXING

JILL MIRZA
NICK HARRIS

CHARTWELL
BOOKS, INC.

A QUINTET BOOK

Published by Chartwell Books
A Division of Book Sales, Inc.
PO Box 7100
Edison, New Jersey 08818-7100

This edition produced for sale in the U.S.A., its territories
and dependencies only.

ISBN 0-7858-0266-5

This book was designed and produced by
Quintet Publishing Limited
6 Blundell Street
London N7 9BH

Creative Director: Richard Dewing
Designer: Ian Hunt
Project Editor: Diana Steedman
Photographer: Nick Bailey

Typeset in Great Britain by
Central Southern Typesetters, Eastbourne
Manufactured in Malaysia by
C.H. Colour Scan Sdn. Bhd.
Printed in Singapore by
Star Standard Industries (Pte) Ltd

CONTENTS

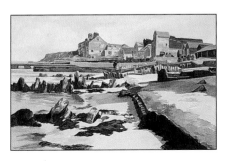

INTRODUCTION

Acrylics are really exciting to paint with and are ideal for learning about mixing colors, from the very bright to the most subtle, as they have just the right qualities to help you make rapid and sure progress.

Acrylic paints use the same pigments as oil paints or water-colors, but (to be technical for a moment) they are bound in a synthetic medium – a transparent water emulsion of acrylic polymer resin. As a result acrylic paints have qualities that set them apart. They will not yellow, or go moldy or brittle for instance, and they are very flexible.

You mix acrylic with water to paint with it. This makes it very easy to use. It dries rapidly, by evaporation, and is waterproof once it is dry. As it is no longer water-soluble when dry you can add more to your painting without damaging the paint surface, and you do not have to wait for days to do so.

One of the great qualities of acrylic paint is that it is very versatile, since it can be used as very thick paint or as very thin. You can use it straight from the tube and create thick impasto paintings, like oil, or you can dilute it with water to a very thin consistency, so that you can apply it in washes on paper, like water-color.

Another characteristic of acrylic paint and one that is really valuable in terms of color mixing is that all the colors in a manufacturer's range are fully compatible with each other and so can be mixed together without any worry at all.

With other types of paint there can be many things to worry about, as oil painters and watercolorists will know, but painting with acrylics really has very few "don'ts." There is one that must be mentioned however – the twin qualities of quick drying time and insolubility mean you must not let the paint dry on your brush!

RIGHT Mixing colors – from light to dark and from bright to subtle.

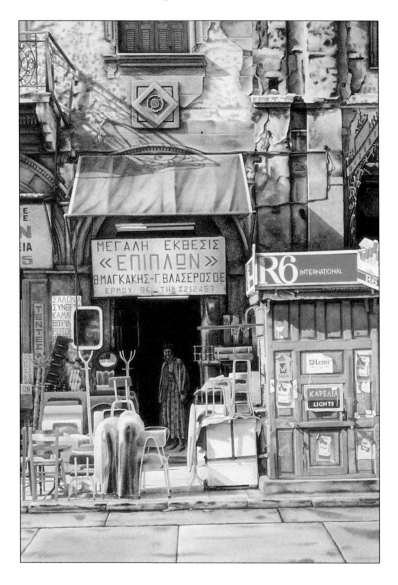

EQUIPMENT

You do not need a great deal of equipment to follow these lessons and exercises in mixing acrylics, but there are some things which are essential.

TYPES OF PAINT

It is probably best to stick to one manufacturer's range of paints. There are two forms of acrylics available.

BELOW Many types of brush are suitable for acrylics.

The Standard formula, which has a buttery consistency similar to oil color, is suitable for most techniques, including impasto. Flow formula is much runnier and is good for painting large flat areas and wet into wet. Both are fully intermixable and you can choose whichever you prefer.

MEDIUMS

A number of different mediums and varnishes can be used in conjunction with acrylic and which you might find useful for painting, but they are not essential or necessary for learning about mixing. The one medium which is essential is water.

WHAT TO PAINT ON

Almost any painting surface is suitable for acrylics: canvas, board, card, or paper. When learning how to mix paints a fairly thick white paper is probably best.

BRUSHES

Again, almost any type of brush is suitable for acrylics but we suggest you use round, watercolor-type brushes made with synthetic hair if you are going to work on paper, but if you would rather do so you could perfectly well use oil-style bristle

RIGHT Ceramic dishes are excellent for mixing acrylic paints.

brushes. Keep your brushes clean by washing them in warm soapy water before the paint dries.

PALETTE

You will need a surface on which to mix your paints. This needs to be a hard gloss surface. Glass and ceramic surfaces are particularly useful. The best way to clean your mixing surface is to let the paint dry and then soak the palette in warm soapy water. After a minute or two the paint will easily peel off.

SUGGESTED COLORS

The art of successful color mixing is to be able to create the maximum color range from a minimum number of paints. A manufacturer's range can easily number over 70 colors. Each one will have its own special qualities, but the important thing when selecting your palette is to have a balance – a group of colors that is evenly distributed.

We have used a relatively small number of colors in the exercises in this book, as it is possible to learn far more initially from using a small group of colors extensively. For our purposes we want to begin with the most vivid colors available, because every time you mix colors the result loses some brightness.

Using just the eight colors plus a black and a white featured in the illustration you can discover much of what you need to know. By the way, despite its name, Payne's gray is really a black and monestial is also known as phthalocyanine.

As your awareness increases and your painting needs become greater you will almost certainly want to expand your palette, and the six additional colors illustrated are suggestions. Please remember they are only suggestions, as everybody will have their own favorites. In this book we have also used a number of other colors.

Remember that you are likely to use white far more than anything else, and finally, do try to avoid mixing more than three colors at a time, because if you do it is very likely that you will end up with lifeless colors. (There are almost limitless ways of mixing mud.)

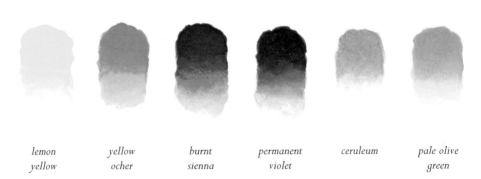

| lemon yellow | yellow ocher | burnt sienna | permanent violet | ceruleum | pale olive green |

SUGGESTED STARTER PALETTE

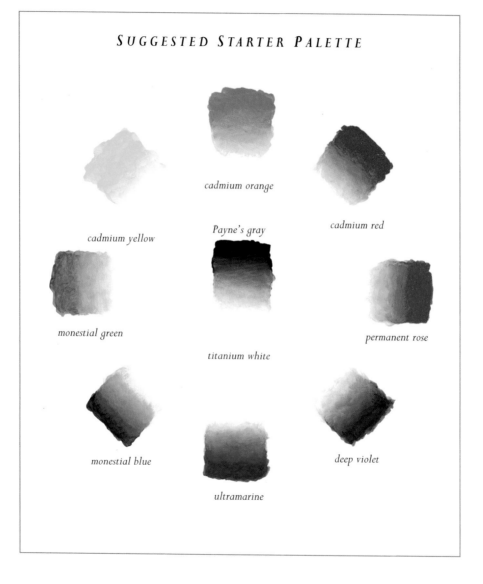

cadmium orange

cadmium red

cadmium yellow

Payne's gray

monestial green

titanium white

permanent rose

monestial blue

ultramarine

deep violet

AN INTRODUCTION TO COLOR THEORY

A little color theory goes a long way and is essential for successful color mixing in acrylics. Each color you choose to use has three different qualities. These are hue, value and saturation.

Let's take in this instance the paint color cadmium yellow.

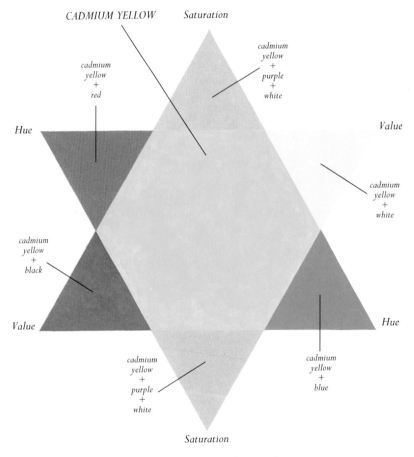

CADMIUM YELLOW

Saturation

cadmium yellow + purple + white

cadmium yellow + red

Hue

Value

cadmium yellow + white

cadmium yellow + black

Value

Hue

cadmium yellow + purple + white

cadmium yellow + blue

Saturation

Three ways of changing cadmium yellow.

HUE

We can change its hue, its yellowness, by adding a little red and so create an orange hue, or we could add some blue and so create a green hue.

Hue. Changes of hue from orange to green.

VALUE

We can change its lightness or darkness, or its value, by adding white or black. If we add white we make a cream color. Adding black creates a type of green.

Value. Changes of value from dark to light.

SATURATION

Thirdly, we can also alter the brightness or dullness of a color. Cadmium yellow, for example, is a very bright color, but we cannot add anything to make it more saturated. However we can of course make it duller. It can be made grayer just by adding a little purple.

Saturation. Changes of saturation from dull to bright.

Real familiarity with these ideas helps you to re-create in your painting any color you are looking at. It just needs to be thought of in terms of these three qualities, of hue, value and saturation.

COLOR HUE

Here is a color wheel showing the six main colors. In theory all colors derive from the three primary colors, red, yellow and blue. The three secondary colors, orange, green and purple are the result of mixing the primary colors, so that red and yellow make orange, yellow and blue make green and red and blue make purple.

Two especially important things should be noted about the color wheel. The colors that are directly opposite each other are called complementary colors. We will be paying a lot of attention to these later. Blue and orange are complementary, red and green are, and so are yellow and purple.

The second very important thing is to notice that the visual gaps between the colors are not equal. You can see that it is only one small step from blue to purple, but from yellow to green there is clearly a greater perceptible distance.

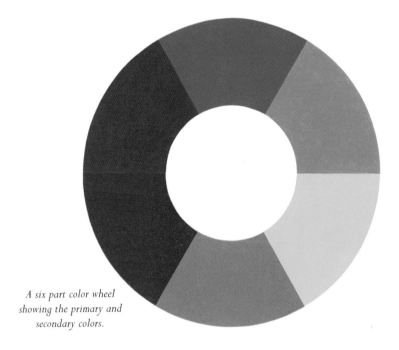

A six part color wheel showing the primary and secondary colors.

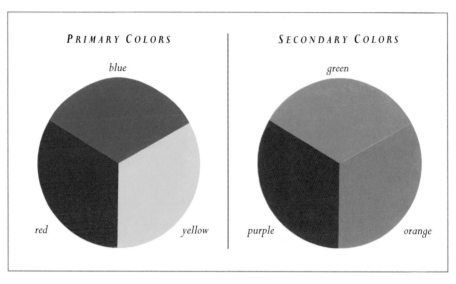

PRIMARY COLORS	SECONDARY COLORS
blue	green
red — yellow	purple — orange

There is a much greater visual gap between yellow and green than there is between blue and purple.

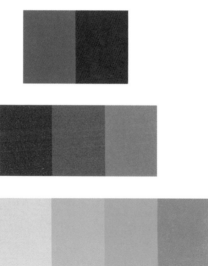

COLOR VALUE

We have seen that color value is in effect its lightness or darkness. Purple is certainly much darker than yellow. The best way to become conscious of this is to try to relate the colors to an equivalent gray. We can clearly see just how different yellow and purple are by looking at the tone gradation chart. To mix a purple of the same value or tone as yellow is going to take a lot of white.

It is mainly by being able to control the value of the colors you use that you gain the possibility of developing a convincing sense of space and depth in your paintings.

TINTS

If we add white to a color or lighten it we are making a tint. For example, pink is a red tint.

SHADES

If we add black to a color or darken it we are making a shade. For example, brown is an orange shade.

Using titanium white to make tints of deep violet.

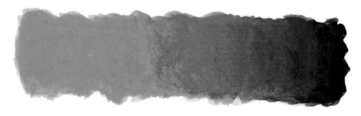

Using Payne's gray to make shades of yellow ocher.

A tone gradation tree showing the relative lightness and darkness of colors by comparison with a range of grays.

COLOR SATURATION

In the previous section we saw how hues can be thought of in terms of their lightness or darkness. On the value chart we can see that cadmium red is equivalent to a mid-gray. To demonstrate the nature of color saturation we can move the red by stages towards its equivalent value gray, reducing and then extinguishing its brightness as we go.

In this painting it can be seen how the colors have all been reduced in their brilliance to create subtle harmonies. The monestial green of the wall and the cadmium yellow deep of the road show this very well.

When we make tints by adding white to these desaturated colors we create a whole range of colors in the wall and the road.

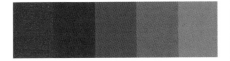

Cadmium red reducing in brightness towards an equivalent gray.

Tints of desaturated monestial green.

A mix of monestial green and white losing its brilliance.

Cadmium yellow deep becoming desaturated.

Tints of desaturated cadmium yellow deep.

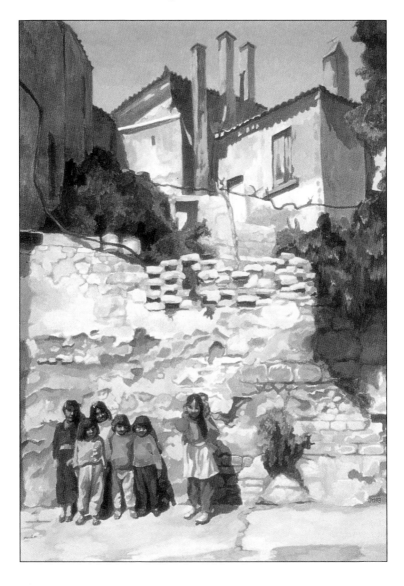

MIXING WITH BLUE

Two very useful blues are ultramarine and monestial blue. Ultramarine is the "warmer" of the two, being slightly more violet while monestial blue is "cooler" and veers slightly to green. It can be seen when mixing with white that colors have different strengths. Ultramarine does not retain its intensity as much as monestial blue. Other blues which are of great interest are cobalt blue, which is a pure color, leaning neither to green or violet and ceruleum, a delicate light blue.

By moving equally either side of blue and mixing turquoise and violet you will create a blue which is much less bright.

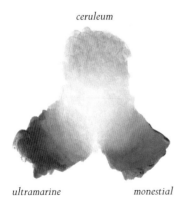

ceruleum

ultramarine　　　*monestial*

Ceruleum, ultramarine, monestial blue
and titanium white

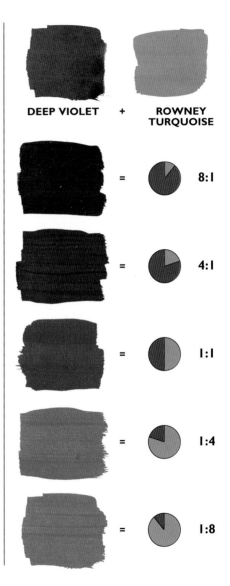

DEEP VIOLET　+　**ROWNEY TURQUOISE**

= 8:1

= 4:1

= 1:1

= 1:4

= 1:8

MONESTIAL BLUE	+	TITANIUM WHITE	ULTRAMARINE	+	TITANIUM WHITE

 = **1:1** = **1:1**

 = **1:2** = **1:2**

 = **1:4** = **1:4**

 = **1:8** = **1:8**

 = **1:16** = **1:16**

STILL LIFE – BLUE

In this still life you find a range of blues from purple blues to green blues. When mixing very dark blues you maintain the richness of color by mixing different blues together, sometimes adding a touch of another color such as permanent rose or monestial green.

1	Payne's gray
2	ultramarine
4	monestial blue

1	monestial blue
12	titanium white

1	ultramarine
6	titanium white

1	permanent rose
3	monestial blue
9	titanium white

When white is added ultramarine loses its intensity. To achieve a vivid blue you can paint washes of pure color over a light background. For example, for best results when painting the bottle it can be under-painted with strongly contrasted lights and darks and then glazed thinly over with ultramarine.

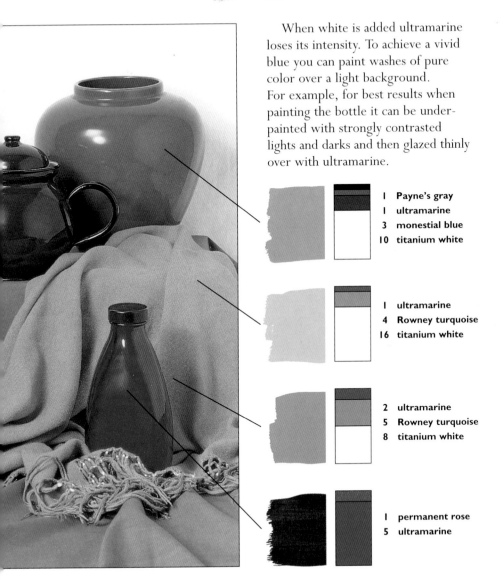

1	Payne's gray
1	ultramarine
3	monestial blue
10	titanium white

1	ultramarine
4	Rowney turquoise
16	titanium white

2	ultramarine
5	Rowney turquoise
8	titanium white

| 1 | permanent rose |
| 5 | ultramarine |

GALLERY – BLUE

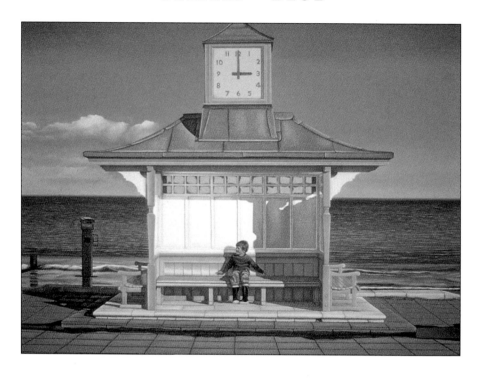

Palette — titanium white, cadmium orange, cadmium red, deep violet, monestial blue, monestial turquoise, Payne's gray

Using only monestial blue modified by other colors to paint this picture a surprising number of blue mixes have been achieved. Monestial turquoise has been added to create a greener blue in the sea and deep violet has also been added, for example. Touches of deep violet with white make the blue shadows in the building warmer. Notice how the sky is a deep blue at the top and fades away to a very pale blue at the horizon as the result of very controlled graduated mixing.

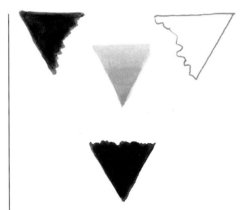

Monestial blue, titanium white and deep purple mix together to make a warm blue.

MIXING SEA COLORS

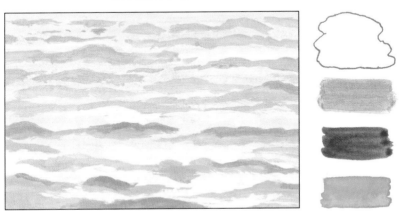

Here are some alternative colors to use when painting sea:-ultramarine, ceruleum and monestial green with titanium white.

MIXING GREEN

There are so many ways of successfully mixing green in acrylics that you are spoilt for choice. It is a good idea to take only a small set of colors and explore the potential. Remember, if you use a blue like ultramarine which is slightly violet and a yellow that is slightly orange, the green you end up with will be very much more restrained than one mixed with a green-biased blue or a sharp yellow, when the result will really sing.

Don't forget that you are going to use much more yellow than blue in your mixes (unless you want a very blue green) so add blue to yellow and not the other way round or you are likely to waste a lot of paint.

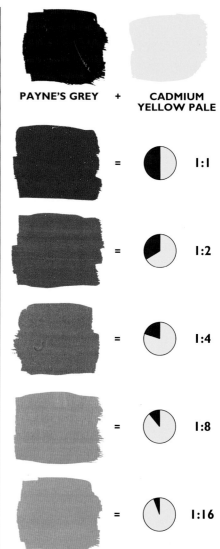

PAYNE'S GREY + **CADMIUM YELLOW PALE**

= 1:1

= 1:2

= 1:4

= 1:8

= 1:16

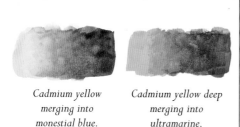

Cadmium yellow merging into monestial blue.

Cadmium yellow deep merging into ultramarine.

Cadmium yellow pale merging into Payne's gray.

MONESTIAL BLUE + **CADMIUM YELLOW** **ULTRAMARINE** + **CADMIUM YELLOW DEEP**

 = 1:2 = 2:1

 = 1:4 = 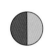 1:1

 = 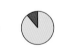 1:8 = 1:2

 = 1:16 = 1:4

 = 1:32 = 1:8

STILL LIFE – GREEN

While there are many variations of green in this still life group, there are some blue greens which are not usually found in nature, where it is normally yellow greens which predominate. When white is added to a blue-biased green, such as monestial green, the color becomes very strong.

1	**Payne's gray**
1	**monestial green**
2	**cadmium yellow**
6	**titanium white**

1	**cadmium yellow**
1	**monestial blue**
1	**Payne's gray**

1	**monestial green**
10	**titanium white**

1	**Payne's gray**
6	**cadmium yellow**

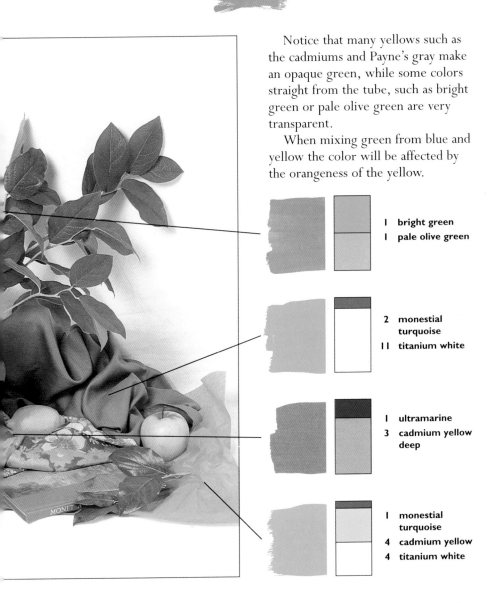

Notice that many yellows such as the cadmiums and Payne's gray make an opaque green, while some colors straight from the tube, such as bright green or pale olive green are very transparent.

When mixing green from blue and yellow the color will be affected by the orangeness of the yellow.

1 **bright green**
1 **pale olive green**

2 **monestial turquoise**
11 **titanium white**

1 **ultramarine**
3 **cadmium yellow deep**

1 **monestial turquoise**
4 **cadmium yellow**
4 **titanium white**

GALLERY – GREEN

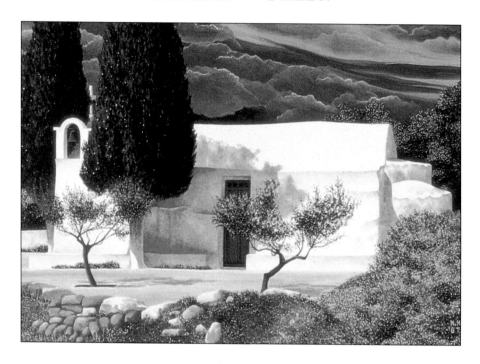

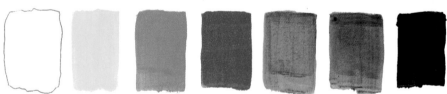

Palette — titanium white, cadmium yellow, cadmium orange, cadmium scarlet, monestial green, monestial blue, Payne's gray

In the picture another way of mixing color is demonstrated. This is a method where small dots of color are applied and tonal and color changes take place on the paper or canvas as the dots build up. This is a very good way of painting foliage, although it can be quite difficult. Acrylics are suitable for this because the paint dries so quickly and it is possible to build up the surface rapidly. It is advisable to start by applying the mid tones, followed by the dark areas and finally the highlights.

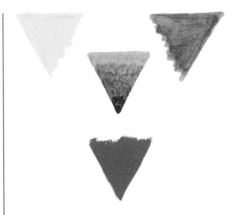

Here cadmium yellow, monestial green and cadmium red mix together to make an olive green.

MIXING FOLIAGE COLORS

An example of a "pointillist" method of applying color. The bushes on the right of the picture are painted using this method.

MIXING WITH YELLOW

Despite the appearance of being very brash, yellow is really a very sensitive color. It is easy to sully yellow because small amounts of other colors will alter its character dramatically. Green or red, for instance, will retain their greenness and redness much more. A trace of blue will turn a yellow into green and similarly a hint of red will turn it into orange. Consequently it is very important that when mixing with yellow you add other colors to it and not the other way round.

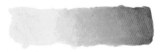

Cadmium yellow merging into permanent rose.

A mix of the two, eight parts yellow and one part rose.

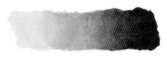

Cadmium yellow merging into monestial green.

A mix of the two, eight parts yellow and one part green.

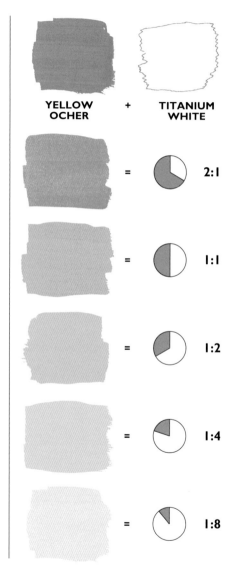

YELLOW OCHER + **TITANIUM WHITE**

= 2:1

= 1:1

= 1:2

= 1:4

= 1:8

 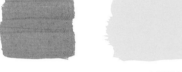

RAW SIENNA + **CADMIUM YELLOW PALE** | **CADMIUM YELLOW** + **TITANIUM WHITE**

 = 2:1 | = 4:1

 = 1:1 | = 1:1

 = 1:2 | = 1:4

 = 1:4 | = 1:16

 = 1:8 | = 1:64

STILL LIFE – YELLOW

This glowing still life group of natural and man-made objects features many strong yellows and many dark yellows. The predominant color here is cadmium yellow deep. For the flowers, cadmium yellow used straight from the tube would be the most suitable color, as they are slightly paler than the surrounding objects.

1 cadmium yellow deep
1 permanent violet

1 lemon yellow
2 cadmium yellow
6 titanium white

1 cadmium yellow deep
1 cadmium yellow
4 titanium white

1 deep violet
2 cadmium yellow deep
4 cadmium yellow

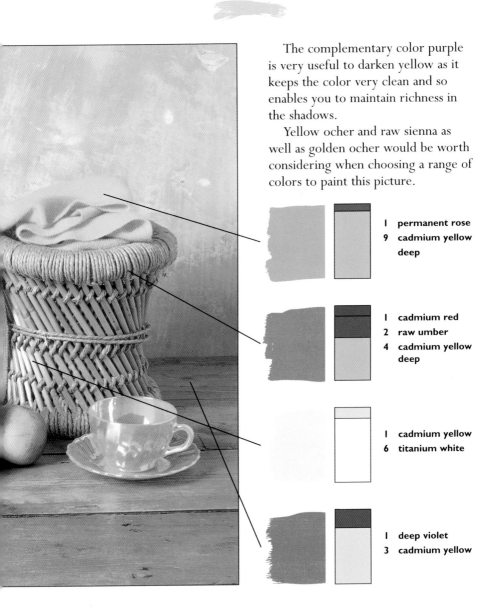

The complementary color purple is very useful to darken yellow as it keeps the color very clean and so enables you to maintain richness in the shadows.

Yellow ocher and raw sienna as well as golden ocher would be worth considering when choosing a range of colors to paint this picture.

1 **permanent rose**
9 **cadmium yellow deep**

1 **cadmium red**
2 **raw umber**
4 **cadmium yellow deep**

1 **cadmium yellow**
6 **titanium white**

1 **deep violet**
3 **cadmium yellow**

MIXING ORANGE

A true yellow such as cadmium yellow and a true red such as cadmium red give a fresh clean range of orange, whilst more earthy colors in the range can be produced if the mix is made with burnt sienna. Cadmium orange itself, when tinted with white, creates a delightful range of tangerine colors. With the addition of yellow ocher for instance, these can form the base for a variety of light skin tones. Carefully adding Payne's gray to orange takes us by degrees into the brown range of colors.

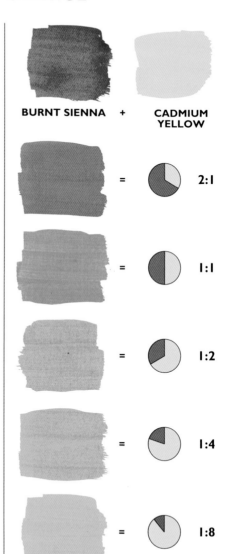

BURNT SIENNA + **CADMIUM YELLOW**

= 2:1

= 1:1

= 1:2

= 1:4

= 1:8

Moving from cadmium yellow to cadmium red.

Mixes of cadmium orange, yellow ocher and titanium white.

CADMIUM RED DEEP + **CADMIUM YELLOW** **CADMIUM ORANGE** + **TITANIUM WHITE**

 = **1:1** = **1:1**

 = 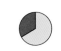 **1:2** = **1:2**

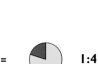 = **1:4** = **1:4**

 = **1:8** = **1:8**

 = **1:16** = **1:16**

MIXING WITH RED

As you move round the color circle from red in either direction it becomes more orange on the one hand, more violet on the other. Cadmium red as a pure red, cadmium scarlet as a lighter more orange red and cadmium red deep as a darker more purple red cover this area extremely well.

Mixing red with white produces pink of course. You will find that the cleanest and most delicate of pinks can be obtained with permanent rose and titanium white. Mixing the cadmium reds with a black or Payne's gray produces rich warm browns.

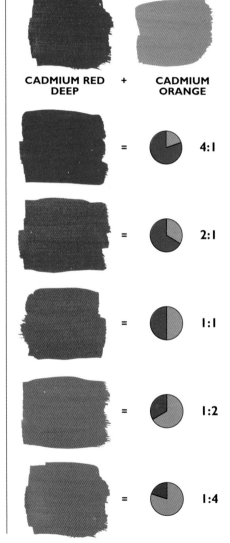

CADMIUM RED DEEP + **CADMIUM ORANGE**

= 4:1

= 2:1

= 1:1

= 1:2

= 1:4

Delicate rose pinks made from titanium white added to permanent rose.

 +

CADMIUM RED + **TITANIUM WHITE**

DEEP VIOLET + **CADMIUM SCARLET**

 = **1:1**

 = **2:1**

 = **1:2**

 = **1:1**

 = **1:4**

 = **1:2**

 = **1:8**

 = **1:4**

 = **1:16**

 = **1:8**

GALLERY – RED

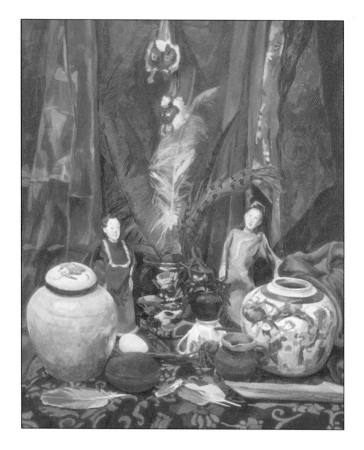

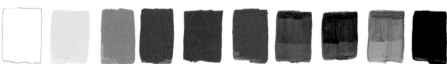

*Palette – titanium white, cadmium yellow, cadmium orange,
cadmium red, cadmium red deep, permanent rose, ultramarine,
monestial blue, monestial green, Payne's gray*

Basically the palette suggested at the beginning of the book was used in this picture with one or two additions. The challenge when using red is to keep the richness and

How permanent rose, cadmium red and monestial green mix together to make a good shadow color.

brilliance of the color even in the shadow areas and in the very light areas. The reds are mixed together where possible to give them resonance. The blues, deep purple and monestial green were used in the shadows, while in some cases yellow, rather than white, was used to lighten the red.

Since pink is the result when white is added to red it is often helpful to give a final thin wash of red to unify an area. In the picture illustrated, this can be seen in the hanging fabrics and in the pink scarf on the right.

MIXING THE SHADOW COLORS

This shows how to use colors other than red to create lively shadow areas. A pink wash was used over the highlights.

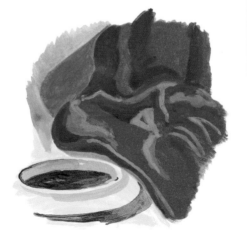

MIXING PURPLE

A lovely clear purple can be made with permanent rose and ultramarine. Because many reds and many blues do not have the appropriate characteristics it can often be very difficult to create a strong bright purple, the results can often be dull. It is therefore important to have a color like deep violet as part of your palette, it makes a beautiful lilac when mixed with white. As purple is the darkest of the primary and secondary colors the range of tints that can be mixed is wide.

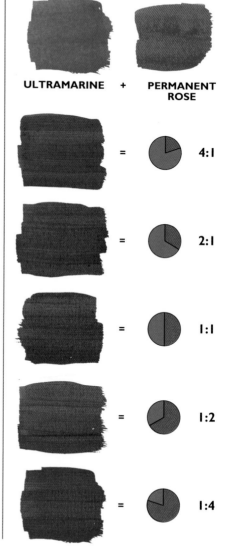

ULTRAMARINE + **PERMANENT ROSE**

= 4:1

= 2:1

= 1:1

= 1:2

= 1:4

From cool blue purple to warm red purple with ultramarine, deep violet and permanent rose, modified by titanium white.

| ULTRAMARINE | + | CADMIUM RED DEEP | | DEEP VIOLET | + | TITANIUM WHITE |

 4:1 1:1

 2:1 1:2

 1:1 1:4

 1:2 1:8

 1:4 1:16

MIXING YELLOW/PURPLE

Complementary color mixes form the next three sections. Yellow and purple are the most distant from each other in terms of lightness and darkness. Being opposite each other on the color circle they tend to neutralize each other when mixed and a range of desaturated colors is created.

The exercises here show the possibilities available with deep violet and cadmium yellow deep (cadmium yellow with a little cadmium orange in effect). You can do similar exercises with other yellows and purples to see just how delicate the outcomes can be.

Moving from lemon yellow to deep violet.

A mix of the same colors with the addition of titanium white in the ratio of 1:1:1.

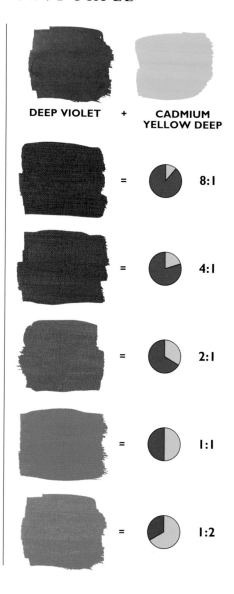

DEEP VIOLET + **CADMIUM YELLOW DEEP**

= 8:1

= 4:1

= 2:1

= 1:1

= 1:2

| DEEP VIOLET | + | TITANIUM WHITE | + | CADMIUM YELLOW DEEP | | DEEP VIOLET | + | TITANIUM WHITE | + | CADMIUM YELLOW DEEP |

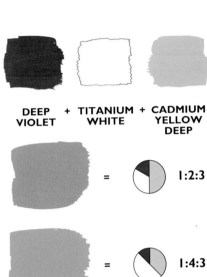

= 1:2:3

= 3:4:1

= 1:4:3

= 3:8:1

= 1:8:3

= 3:16:1

= 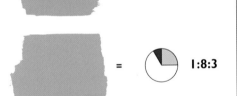 1:16:3

= 3:32:1

= 1:32:3

= 3:64:1

GALLERY – YELLOW/PURPLE

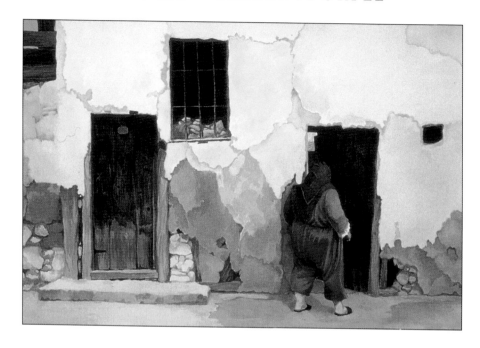

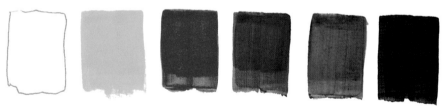

*Palette – titanium white, cadmium yellow deep, cadmium red deep,
deep violet, monestial blue, Payne's gray*

This picture was underpainted with a thin wash of cadmium yellow. The colors most used were cadmium yellow deep and deep violet. By mixing these two colors together in changing ratios that steadily move from mostly yellow to mostly purple, the neutral colors created are lively and the picture remains harmonious and balanced.

The addition of cadmium red and monestial blue to deep violet modifies the color, as in the shadows of the woman's pants.

Monestial blue and deep violet mix with cadmium red to create variations of dark purple.

MIXING COLORS BY GLAZING

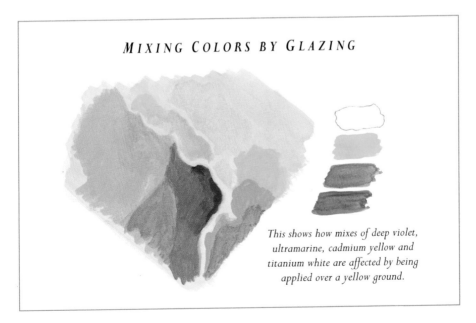

This shows how mixes of deep violet, ultramarine, cadmium yellow and titanium white are affected by being applied over a yellow ground.

MIXING RED/GREEN

Red and green combine to give a whole host of colors found in trees and wood, leaves and foliage, and grasses, as well as in the brickwork of buildings. Consequently they are central to a great many landscape paintings. Here we have chosen three different reds to mix with three different greens in order to give some indication of the possibilities available. You can see clearly how these colors not only lose a lot of their brightness when mixed, but also how they make much darker colors as well.

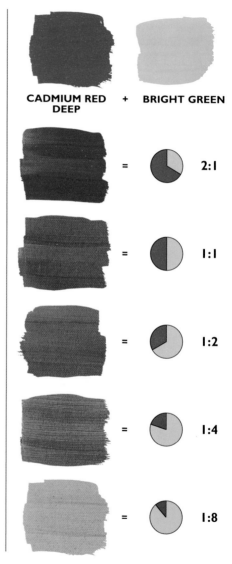

CADMIUM RED DEEP + **BRIGHT GREEN**

= 2:1

= 1:1

= 1:2

= 1:4

= 1:8

Two further colors mixed together, pale olive green and permanent rose.

Bright green merging with cadmium red.

| **CADMIUM SCARLET** | + | **ROWNEY TURQUOISE** | | **CADMIUM RED** | + | **MONESTIAL GREEN** |

 = **4:1** = **8:1**

 = **2:1** = **4:1**

 = **1:1** = **2:1**

 = **1:2** = **1:1**

 = **1:4** = **1:2**

STILL LIFE – RED/GREEN

Apart from creating a bold color balance, this still life contains many objects whose colors illustrate what happens when red and green are mixed together, creating a range of drab greens and dark reds, that beautifully demonstrate the subtleties of complementary color mixes.

1	**bright green**
6	**permanent rose**

1	**Mars black**
3	**cadmium yellow deep**
10	**cadmium red deep**

1	**cadmium red**
1	**monestial green**
2	**permanent rose**

1	**cadmium red**
1	**bright green**
2	**permanent rose**

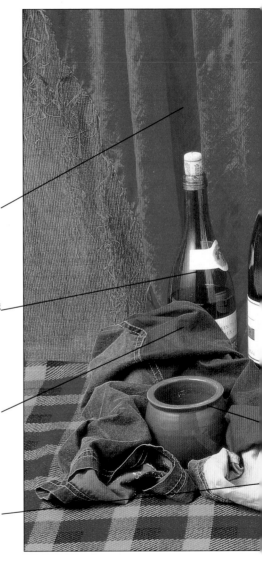

Olive greens, for example, are obtained by mixing red with yellow greens. Rich dark greens can be made by adding small amounts of blue reds to green.

Deep burgundy reds are mixed by combining blue reds, such as permanent rose, with blue greens.

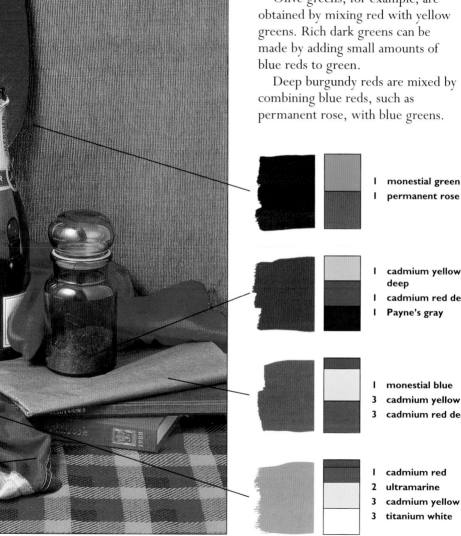

1 monestial green
1 permanent rose

1 cadmium yellow deep
1 cadmium red deep
1 Payne's gray

1 monestial blue
3 cadmium yellow
3 cadmium red deep

1 cadmium red
2 ultramarine
3 cadmium yellow
3 titanium white

MIXING BLUE / ORANGE

The third pair of complementary colors explored here looks at cadmium orange being mixed with three different blues. Though monestial blue is as strong a color, you will find that cadmium orange has more color strength than many blues. This is particularly noticeable with ceruleum which has to be used in large quantities before it has much effect. It is a very transparent color and so is extremely useful for an overpainting or glazing technique to alter an orange undercolor.

If you do some mixing exercises based on other pairs of complementary colors such as yellow green and red purple you will find that a fascinating color world will be revealed.

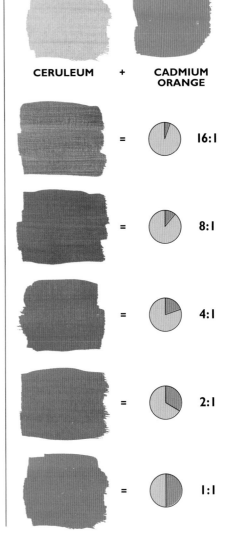

CERULEUM + **CADMIUM ORANGE**

= 16:1

= 8:1

= 4:1

= 2:1

= 1:1

Cadmium orange as a base color with an overlay of ceruleum.

IONESTIAL + TITANIUM + CADMIUM
BLUE WHITE ORANGE

ULTRAMARINE + CADMIUM
** ORANGE**

 = 3:2:1

 = 8:1

 = 3:4:1

 = 4:1

 = 3:8:1

 = 2:1

= 3:16:1

 = 1:1

 = 3:32:1

 = 1:2

GALLERY – BLUE/ORANGE

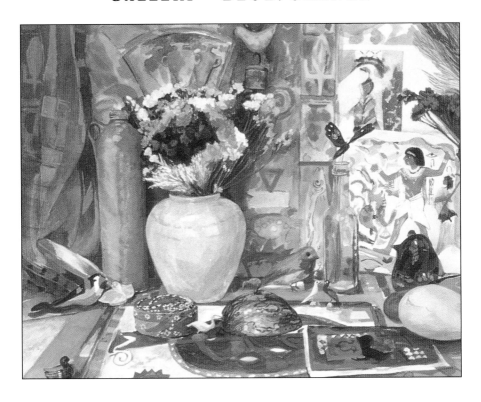

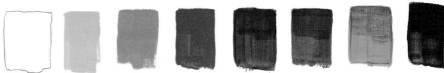

*Palette — titanium white, cadmium yellow deep, cadmium orange,
permanent rose, deep violet, monestial blue, monestial green,
Payne's gray*

Using the complementary colors blue and orange as the basis of a picture makes it a vibrant and well balanced painting in terms of color. Throughout the picture they are used in almost every object depicted to mix, sometimes with other colors, many variants. Many grays and browns, as well as desaturated oranges and blues, are the result. As well as cadmium orange, a mix of cadmium yellow deep and permanent rose are used. Tiny amounts of blue added to the orange darken the color without changing the nature of it too much.

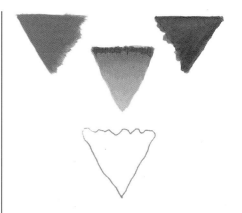

Cadmium orange, monestial blue and titanium white make a fawn mix which is used throughout the painting.

USING TRANSPARENT COLORS

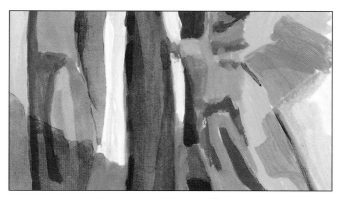

Here we can see how orange and blue are affected by a transparent wash of monestial blue.

MIXING BROWN

Brown is essentially a dark orange or a dark red and so the colors used to mix it must include colors from the warm sector of the color circle from yellow orange through to red purple. Using red rather than orange creates a warmer result, and a rich dark brown can be obtained by mixing red and black. To obtain lighter browns you can add extra yellow, and white added makes fawn or beige. The earth colors such as burnt umber and burnt sienna are very useful.

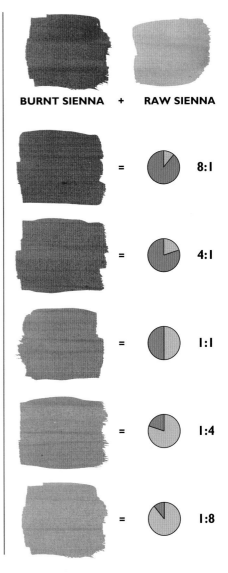

BURNT SIENNA + RAW SIENNA

= 8:1

= 4:1

= 1:1

= 1:4

= 1:8

A three part mixture of titanium white, burnt sienna and burnt umber.

PAYNE'S GRAY + **CADMIUM RED** **PAYNE'S GRAY** + **CADMIUM ORANGE**

 = 1:1 = 1:1

 = 1:2 = 1:2

 = 1:4 = 1:4

 = 1:8 = 1:8

 1:16 1:16

STILL LIFE – BROWN

It is possible to use manufactured browns such as raw umber, burnt umber and burnt sienna, but exciting brown mixes can be achieved in many different ways. In this still life we have objects of warm terracotta and of earth colors and dark reflective surfaces as well. The

1 **permanent violet**
2 **cadmium orange**

2 **Mars black**
3 **cadmium red deep**

1 **cadmium yellow**
2 **burnt sienna**
3 **permanent rose**

1 **Mars black**
14 **burnt sienna**

browns range from very hot orange browns to the cool gray brown found in the pine cone, which can be made by mixing raw umber and titanium white. Surprisingly a mix of Mars black and cadmium red deep makes a very rich brown which can be used in the very dark areas.

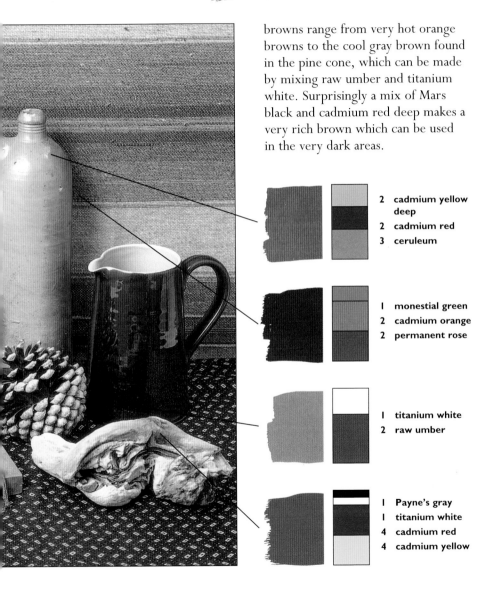

2	cadmium yellow deep
2	cadmium red
3	ceruleum

1	monestial green
2	cadmium orange
2	permanent rose

1	titanium white
2	raw umber

1	Payne's gray
1	titanium white
4	cadmium red
4	cadmium yellow

GALLERY – BROWN

*Palette – titanium white, cadmium yellow deep, cadmium orange,
cadmium red deep, monestial turquoise, Payne's gray*

Given the number of colors that can be used to make brown, the palette used here is fairly limited. The painting has a range from yellow browns to gray browns showing that it is possible to achieve a good selection of brown mixes with a few colors. The picture was built up using watered down paint, one color laid in transparent washes over the other. The dark areas are built up, allowing the colors underneath to show through, so that the mixes can be gradually altered as the painting develops.

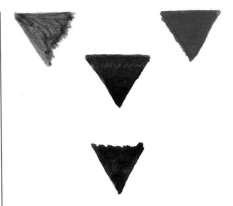

Monestial turquoise, cadmium red deep and Payne's gray make a rich dark brown.

MIXING A RANGE OF BROWNS

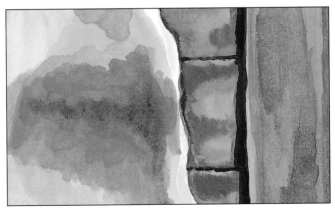

All the colors in the chosen palette were used to make the mixes of brown shown here.

FROM WHITE TO GRAY

Everybody knows that you can easily produce gray by mixing black and white, but for a painter there are far more interesting possibilities. Successful mixing of gray depends upon an awareness of which colors are complementary. Ultramarine and cadmium orange, cadmium yellow and deep violet, cadmium red and monestial green, for example, all produce beautiful grays when mixed with white. There are many other combinations and you might like to find some of them, but in all cases extremely well-controlled mixes are needed and it is essential to pay a lot of attention to the ratios involved (often in the region of 3:1 + white).

Shades of gray made with titanium white and Mars black.

Shades of gray made with titanium white and Payne's gray.

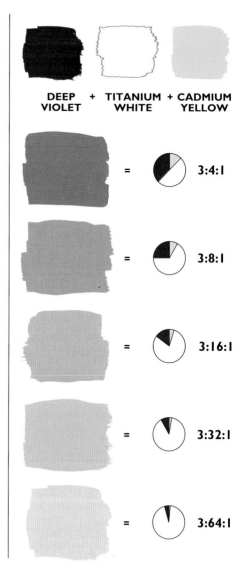

DEEP VIOLET + **TITANIUM WHITE** + **CADMIUM YELLOW**

= 3:4:1

= 3:8:1

= 3:16:1

= 3:32:1

= 3:64:1

| ULTRA-MARINE | + | TITANIUM WHITE | + | CADMIUM ORANGE | | CADMIUM RED | + | TITANIUM WHITE | + | MONESTIAL GREEN |

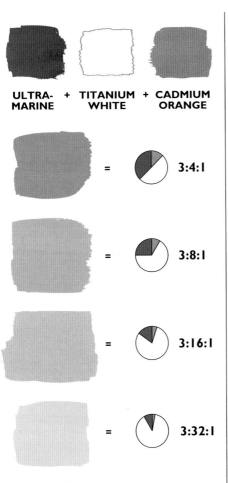

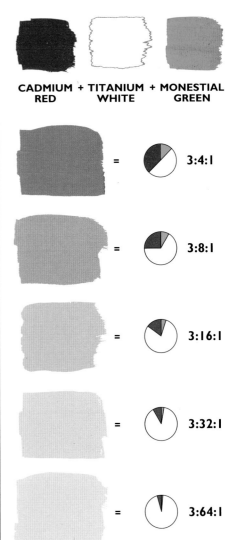

= 3:4:1

= 3:8:1

= 3:16:1

= 3:32:1

= 3:64:1

= 3:4:1

= 3:8:1

= 3:16:1

= 3:32:1

= 3:64:1

When mixing grays and whites it is worth observing carefully the nature of the color. Does it perhaps have a bluish tinge or is it a greenish gray? A touch of yellow or red can enliven a rather dull gray and make it warmer. Dark grays made from a basic mix of black and white can be made much richer by adding a little purple or blue.

1 **Payne's gray**
1 **deep violet**
1 **titanium white**

1 **deep violet**
2 **cadmium yellow deep**
24 **titanium white**

1 **cadmium orange**
2 **monestial blue**
2 **Payne's gray**
24 **titanium white**

3 **ceruleum**
8 **titanium white**
trace **cadmium red**
trace **cadmium yellow**

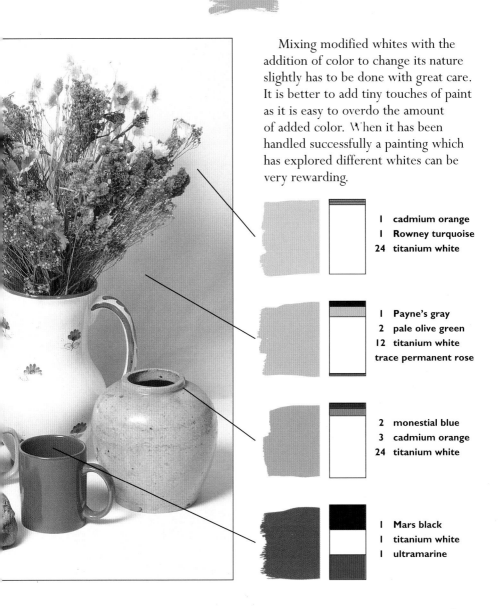

Mixing modified whites with the addition of color to change its nature slightly has to be done with great care. It is better to add tiny touches of paint as it is easy to overdo the amount of added color. When it has been handled successfully a painting which has explored different whites can be very rewarding.

I	cadmium orange
I	Rowney turquoise
24	titanium white

I	Payne's gray
2	pale olive green
12	titanium white
trace	permanent rose

2	monestial blue
3	cadmium orange
24	titanium white

I	Mars black
I	titanium white
I	ultramarine

GALLERY – WHITE/GRAY

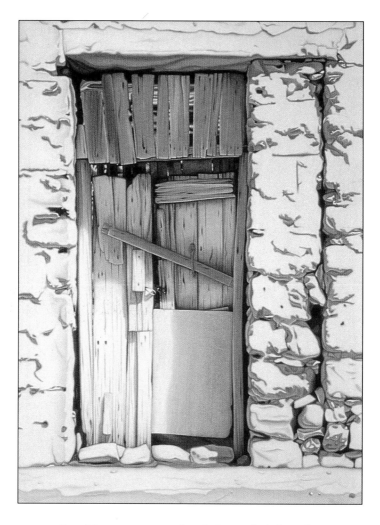

*Most of this painting was made with the use of only four colors,
cadmium orange, monestial blue, Payne's gray and titanium white.
Payne's gray was only used in the very darkest areas.*